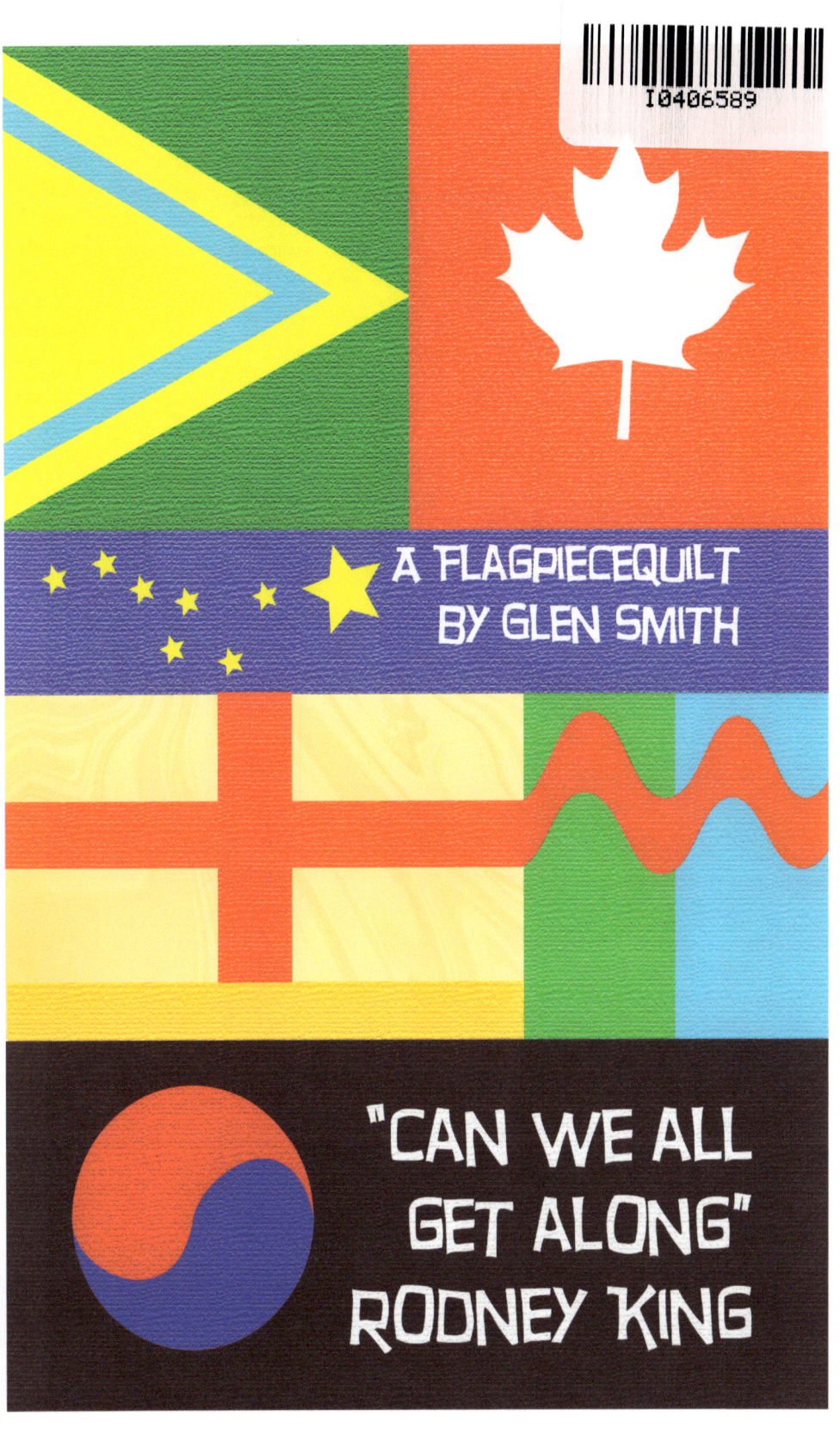

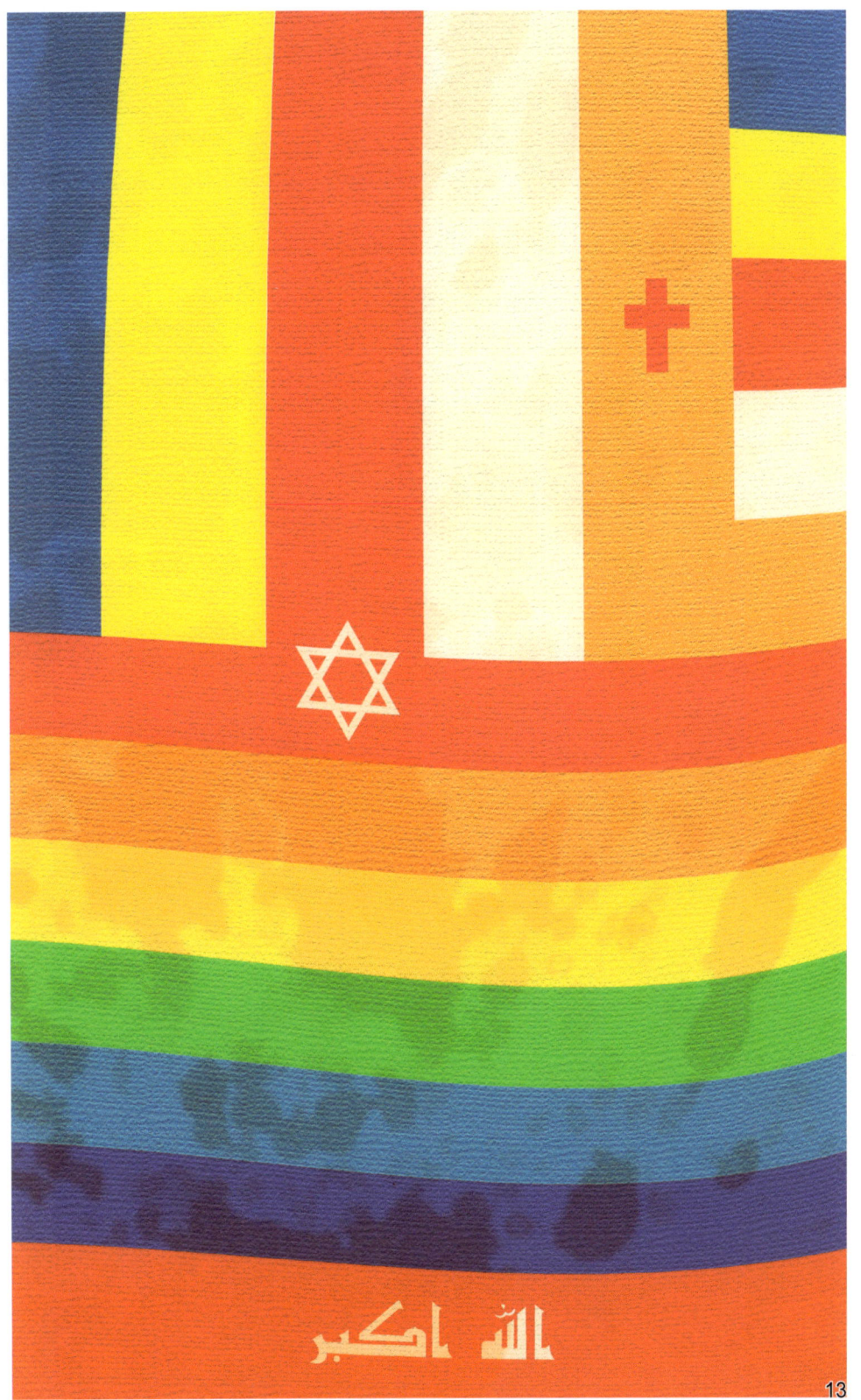

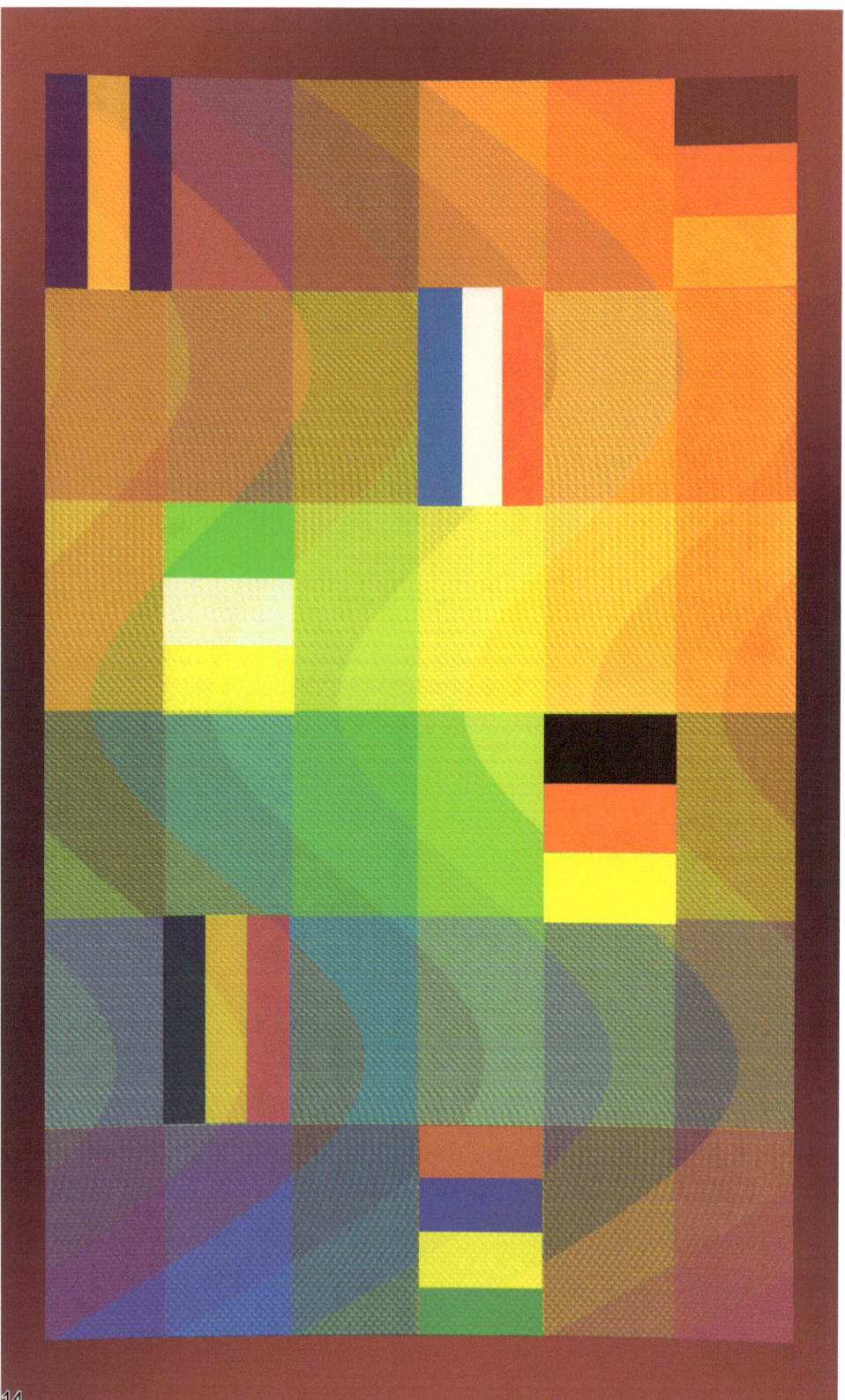

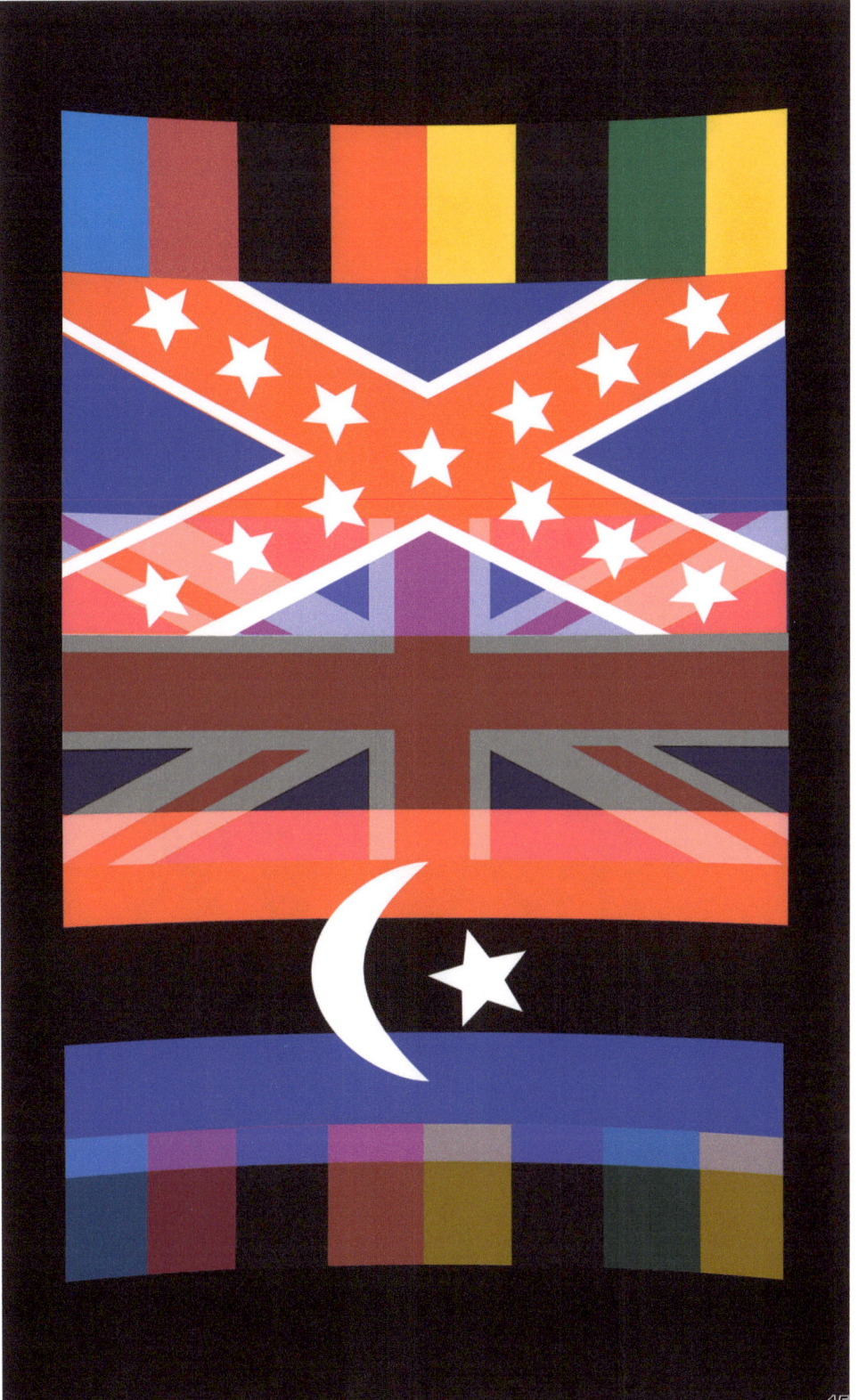

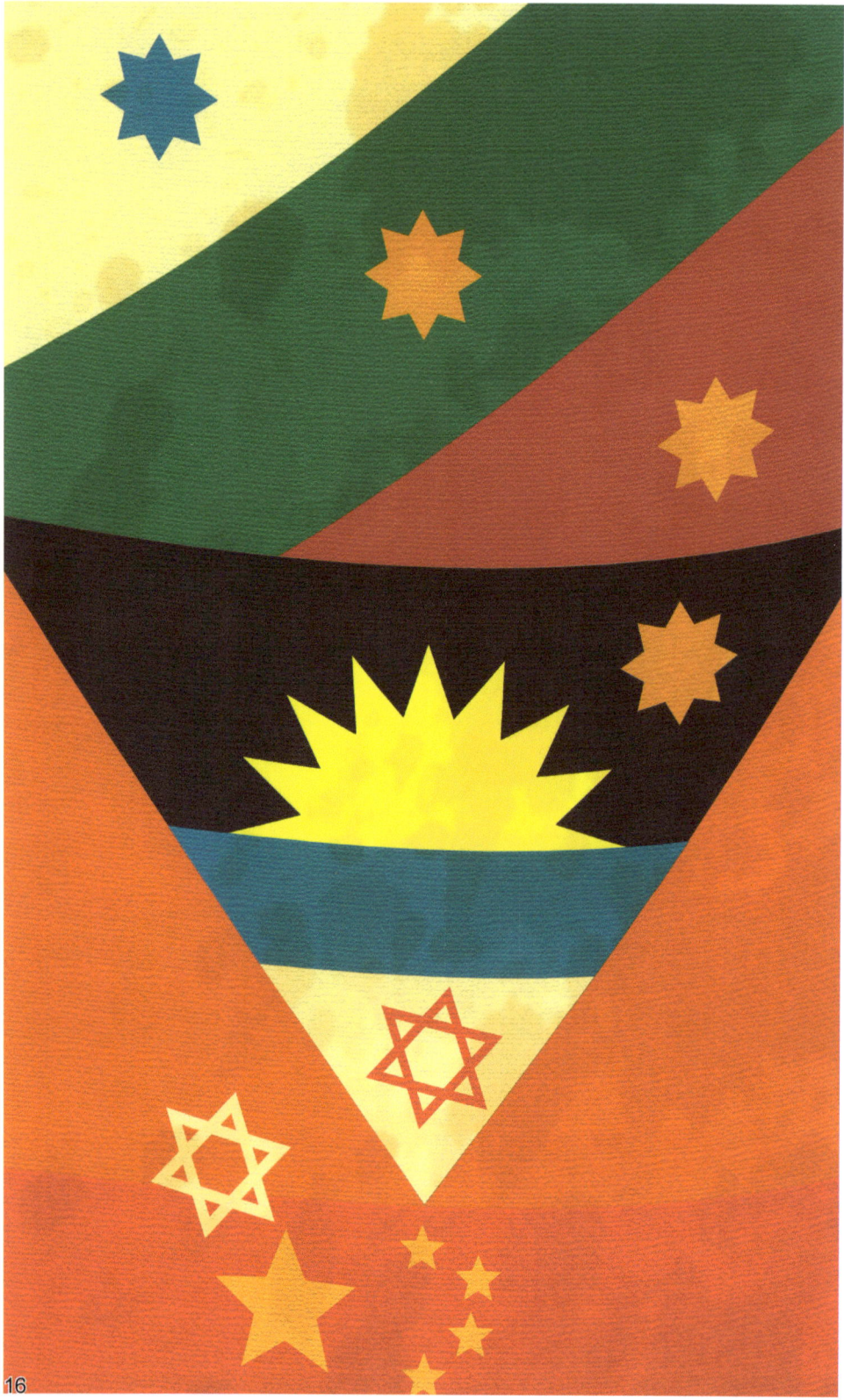

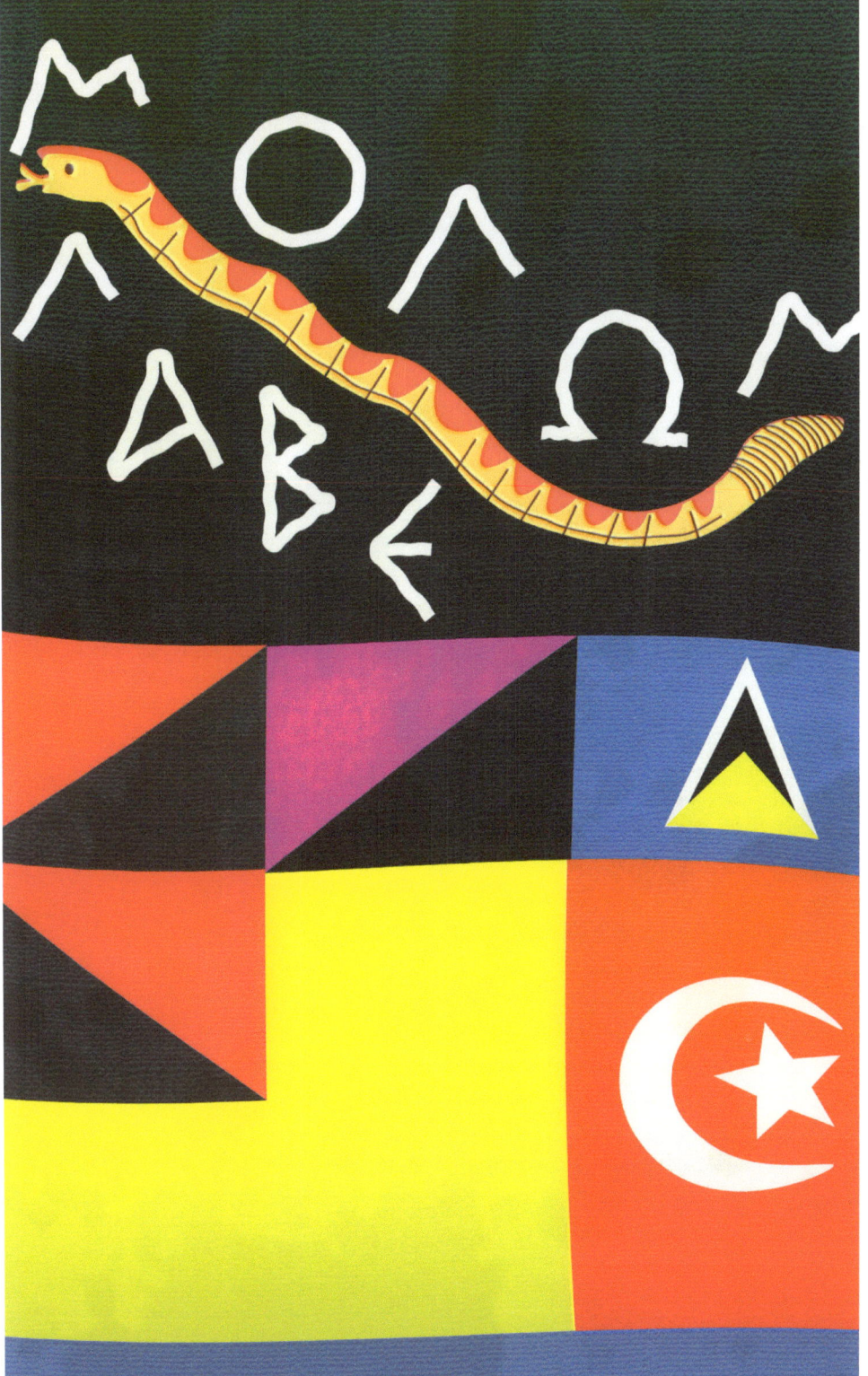

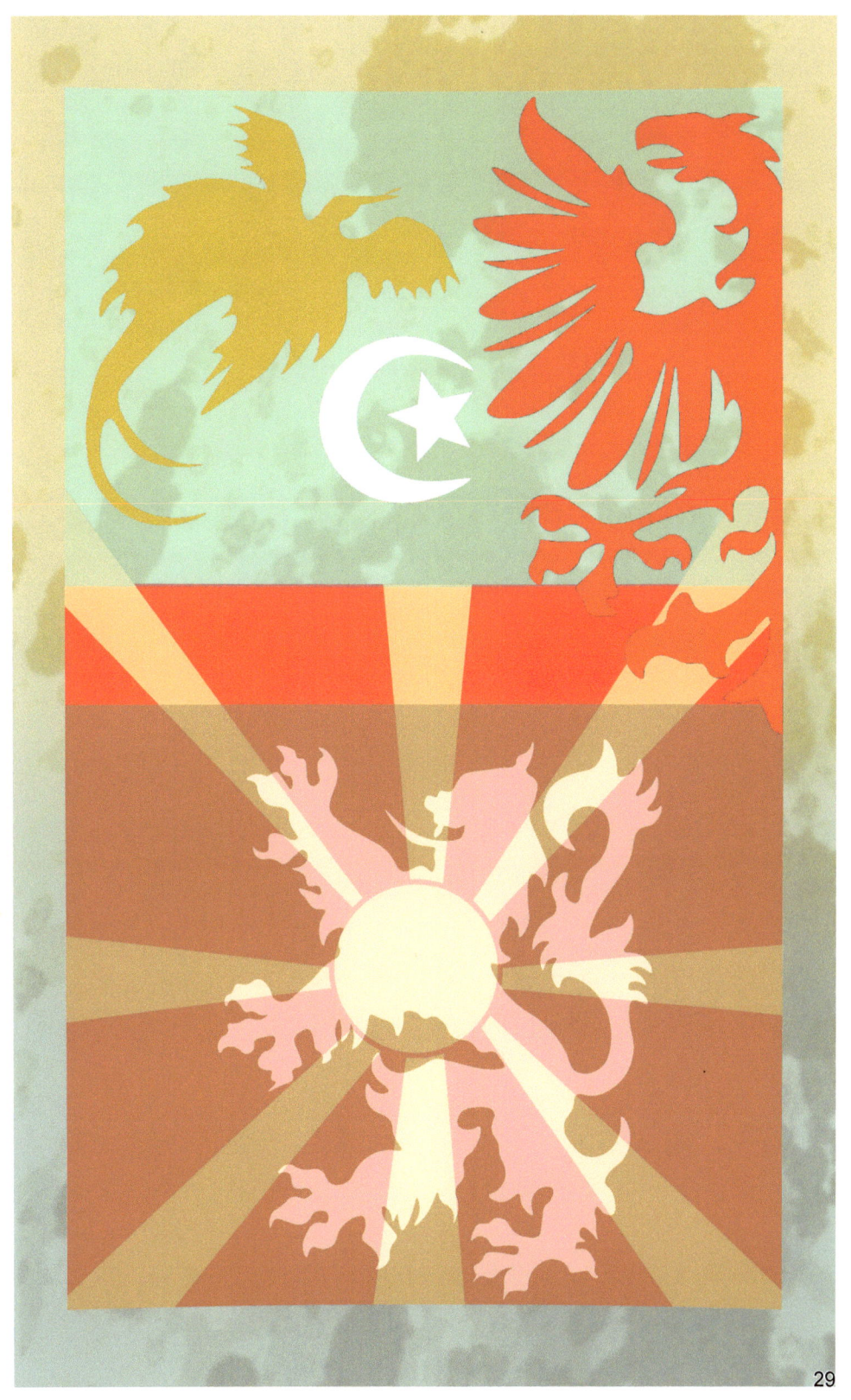

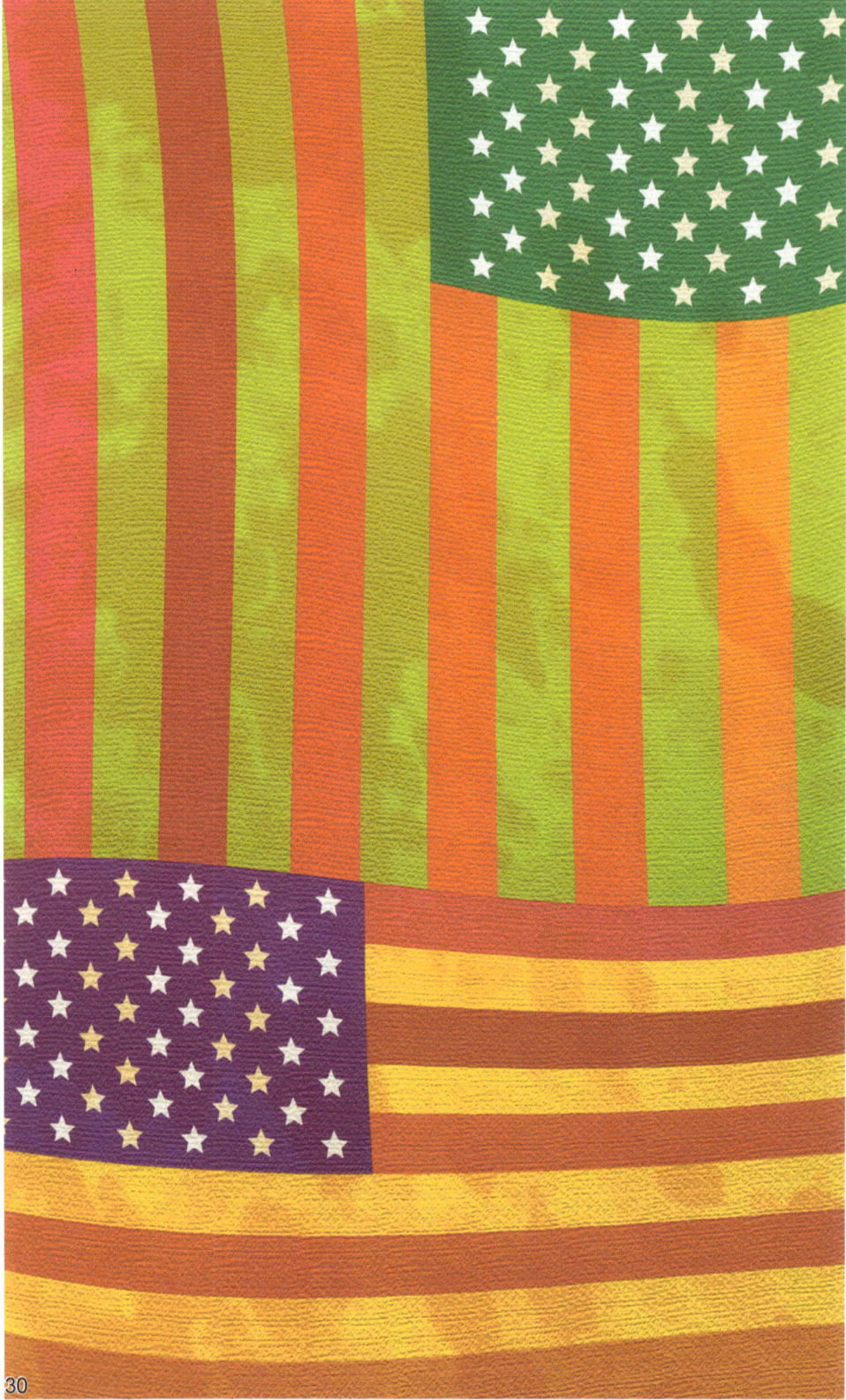

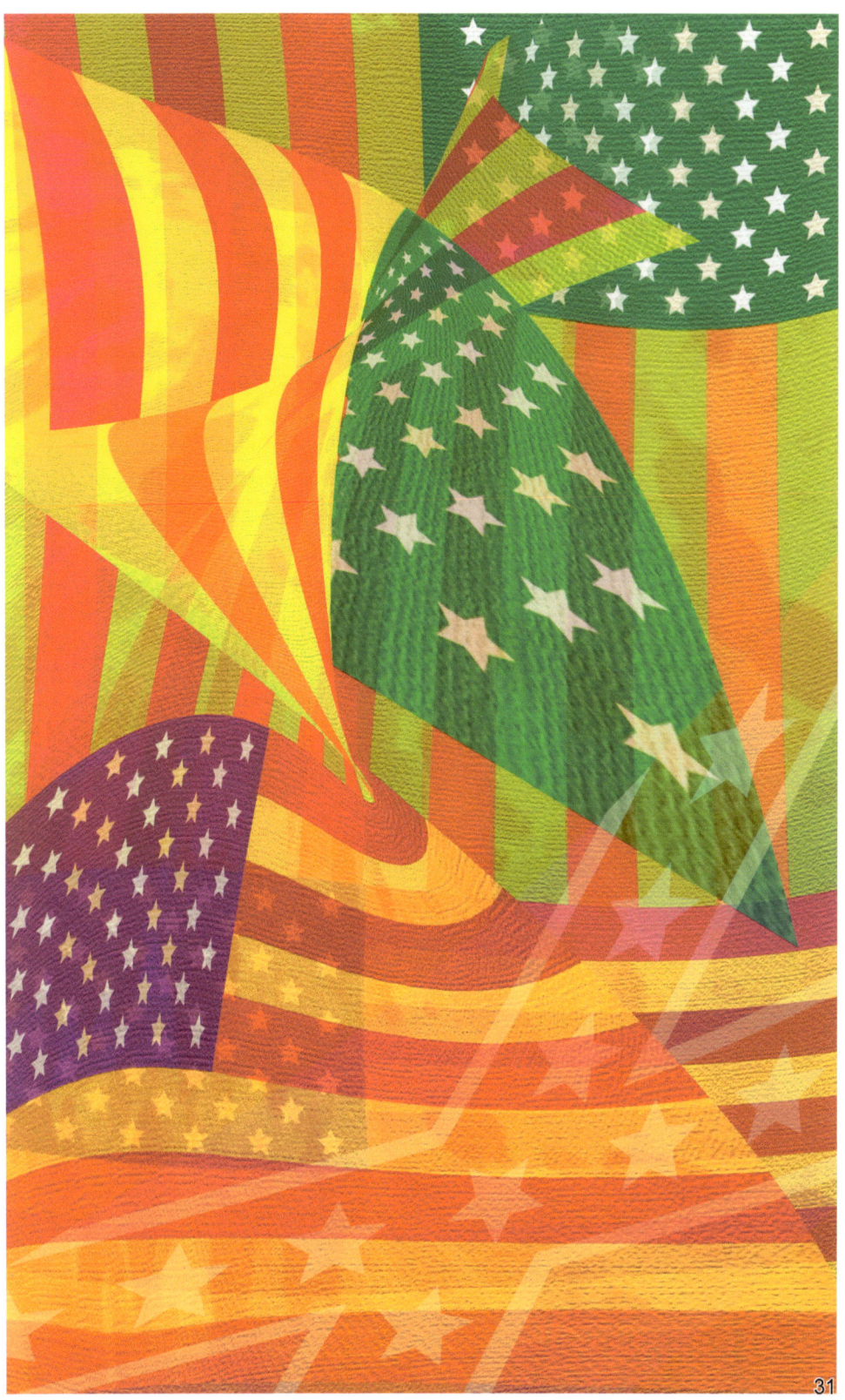

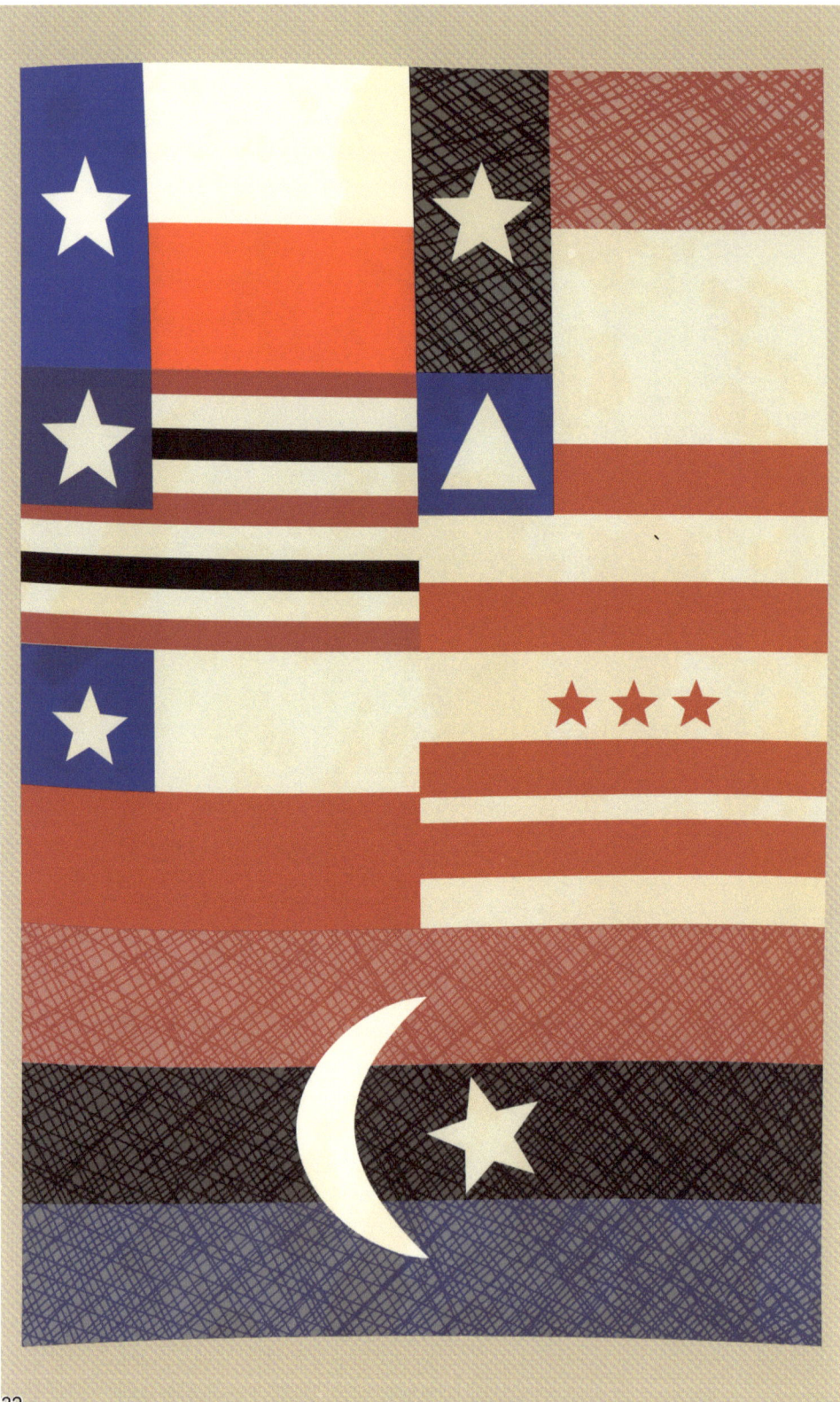

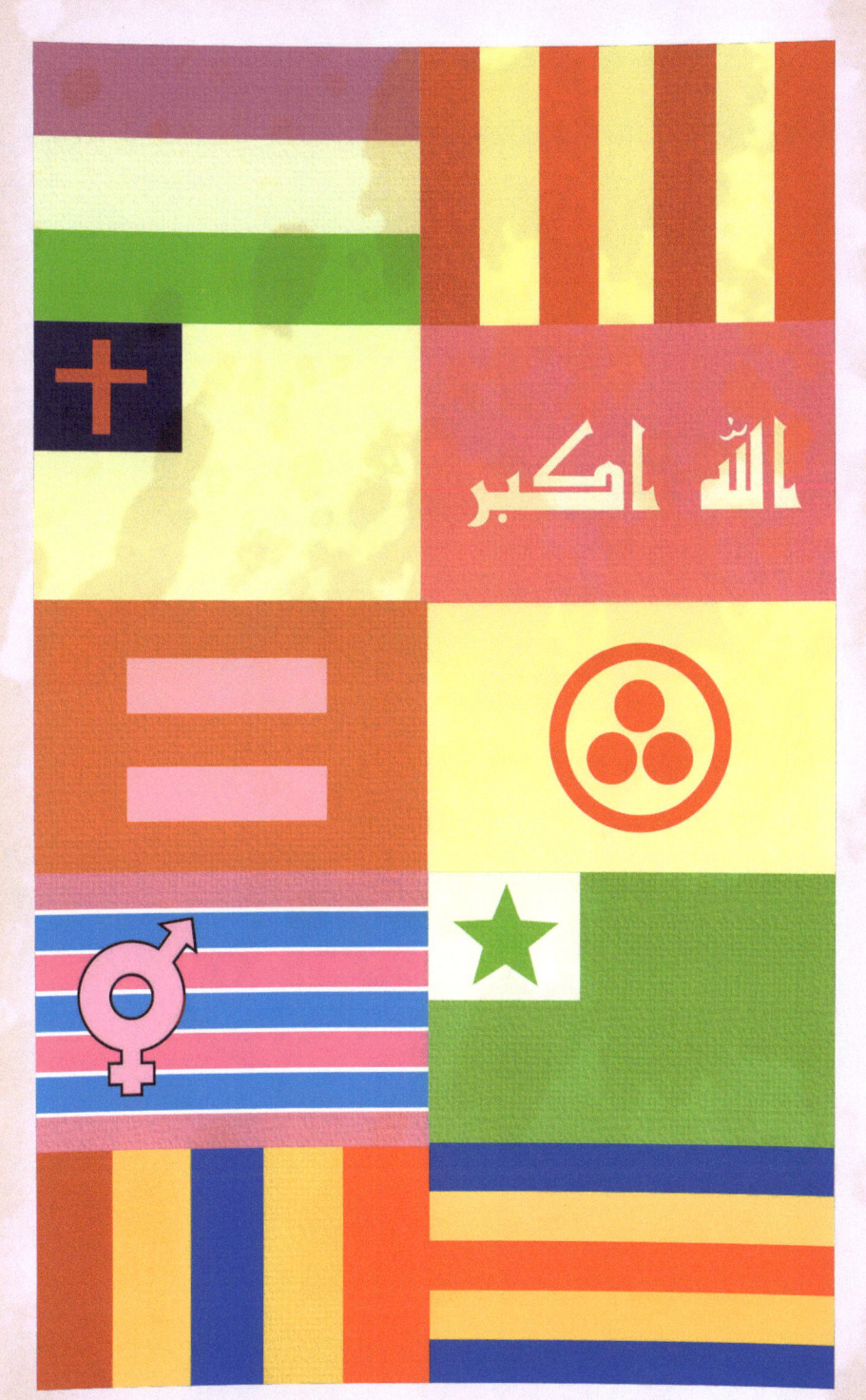

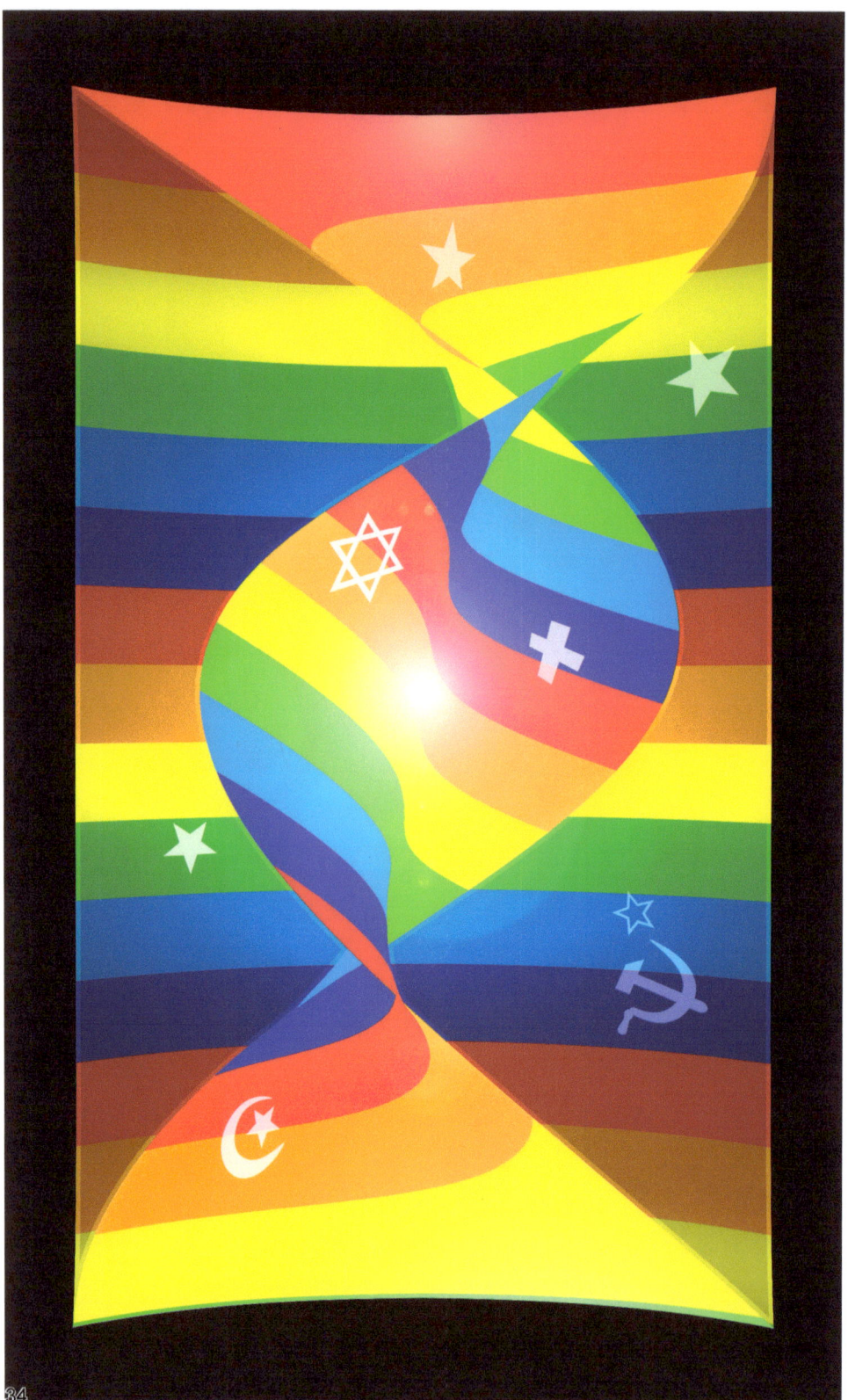

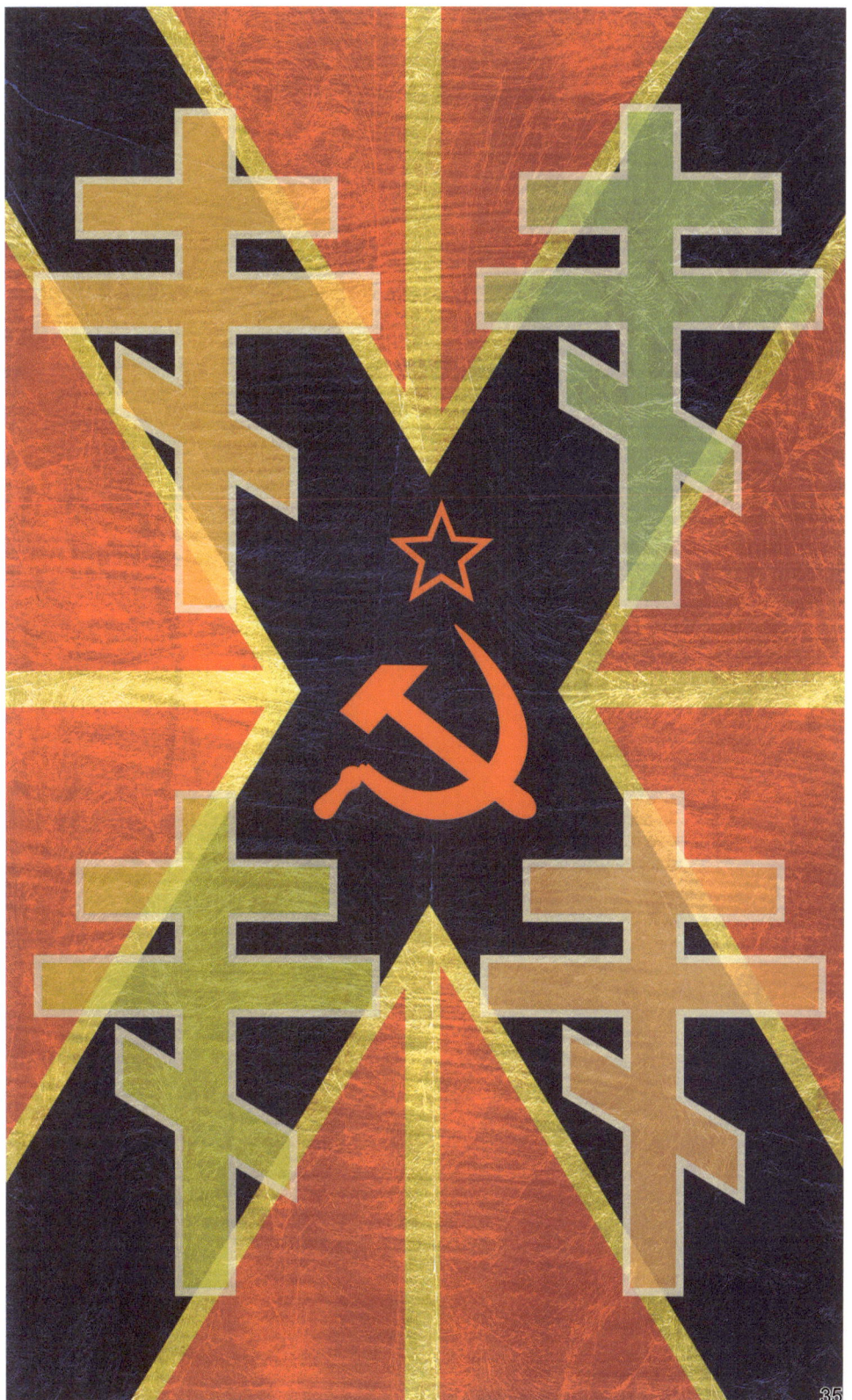

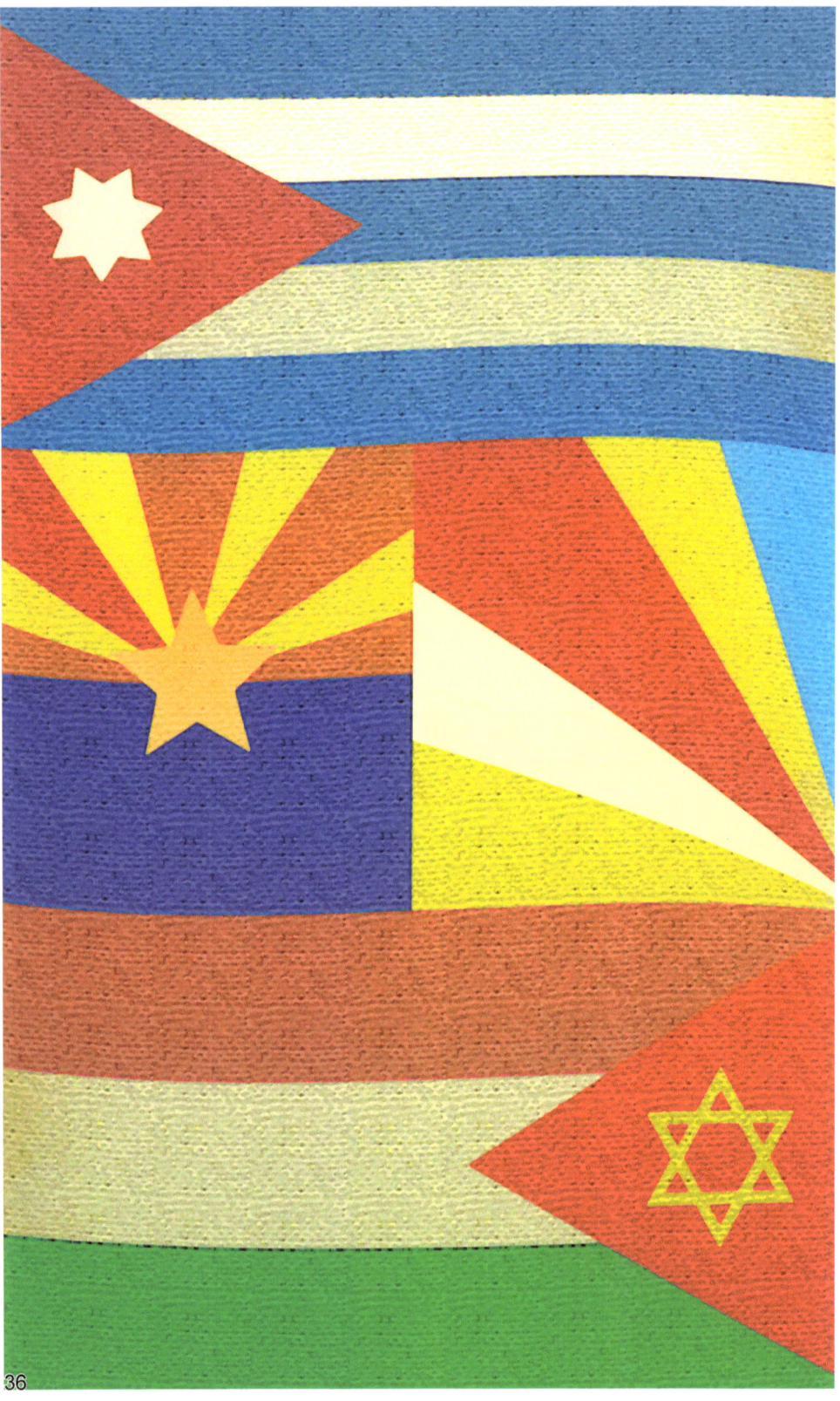

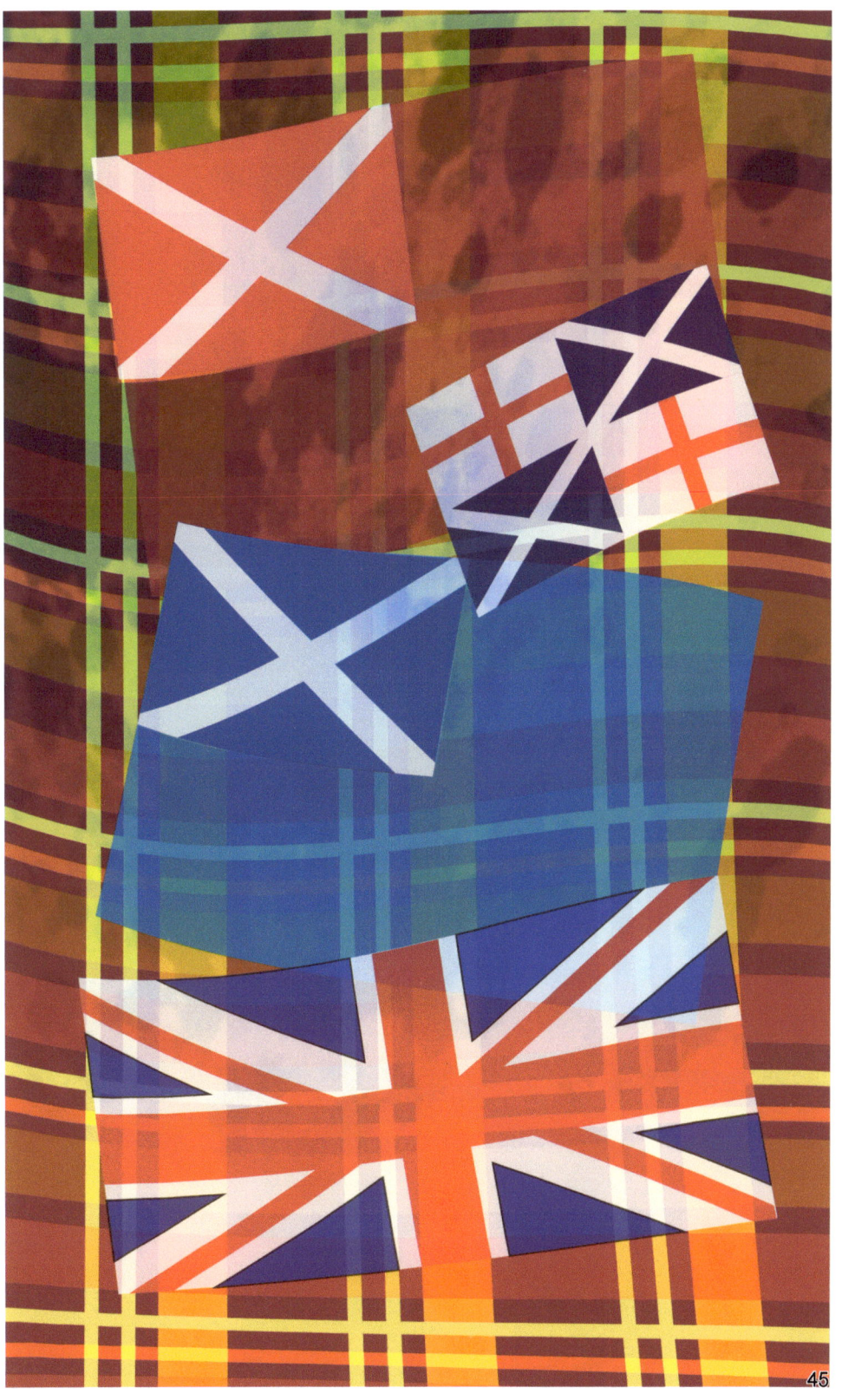

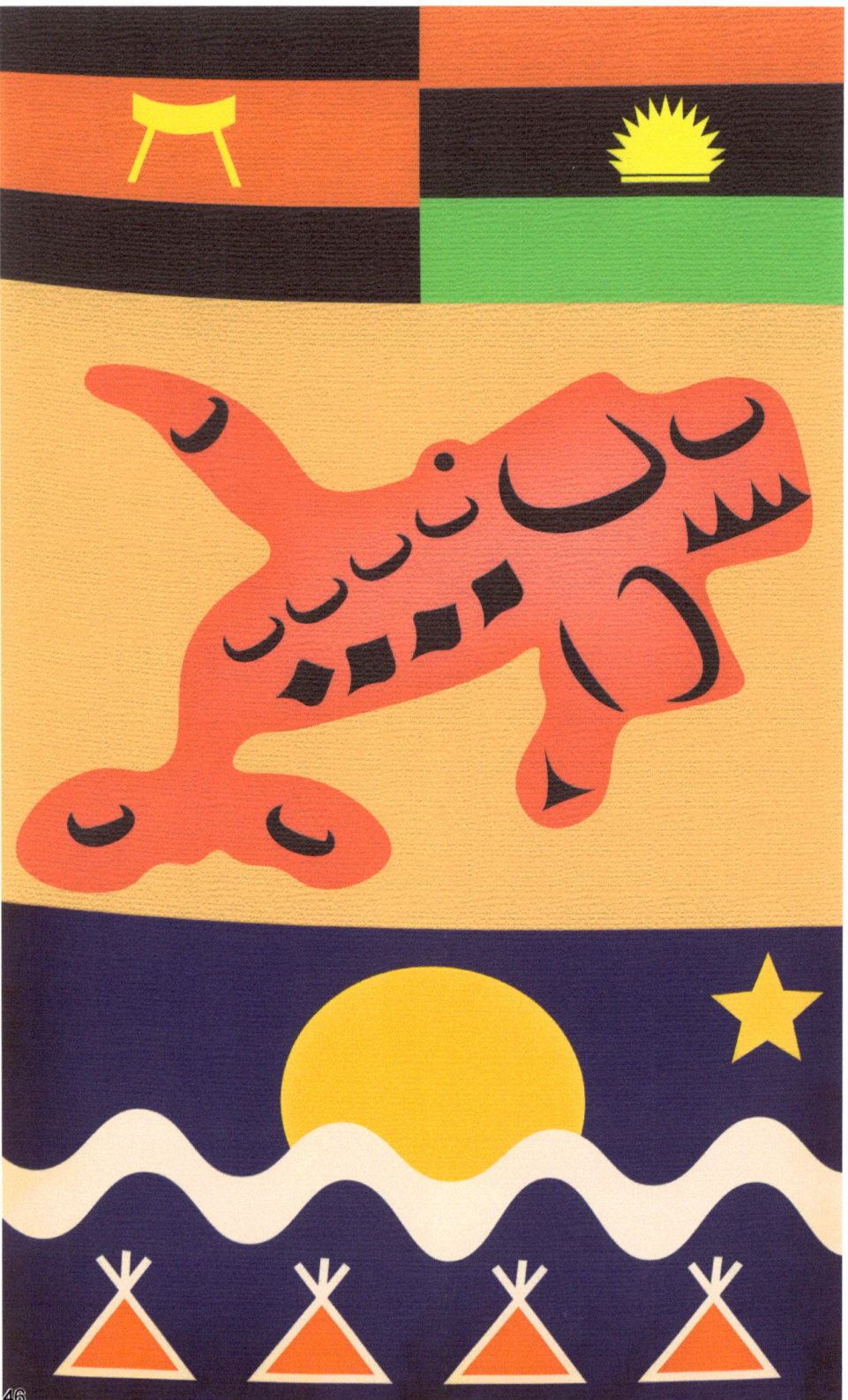

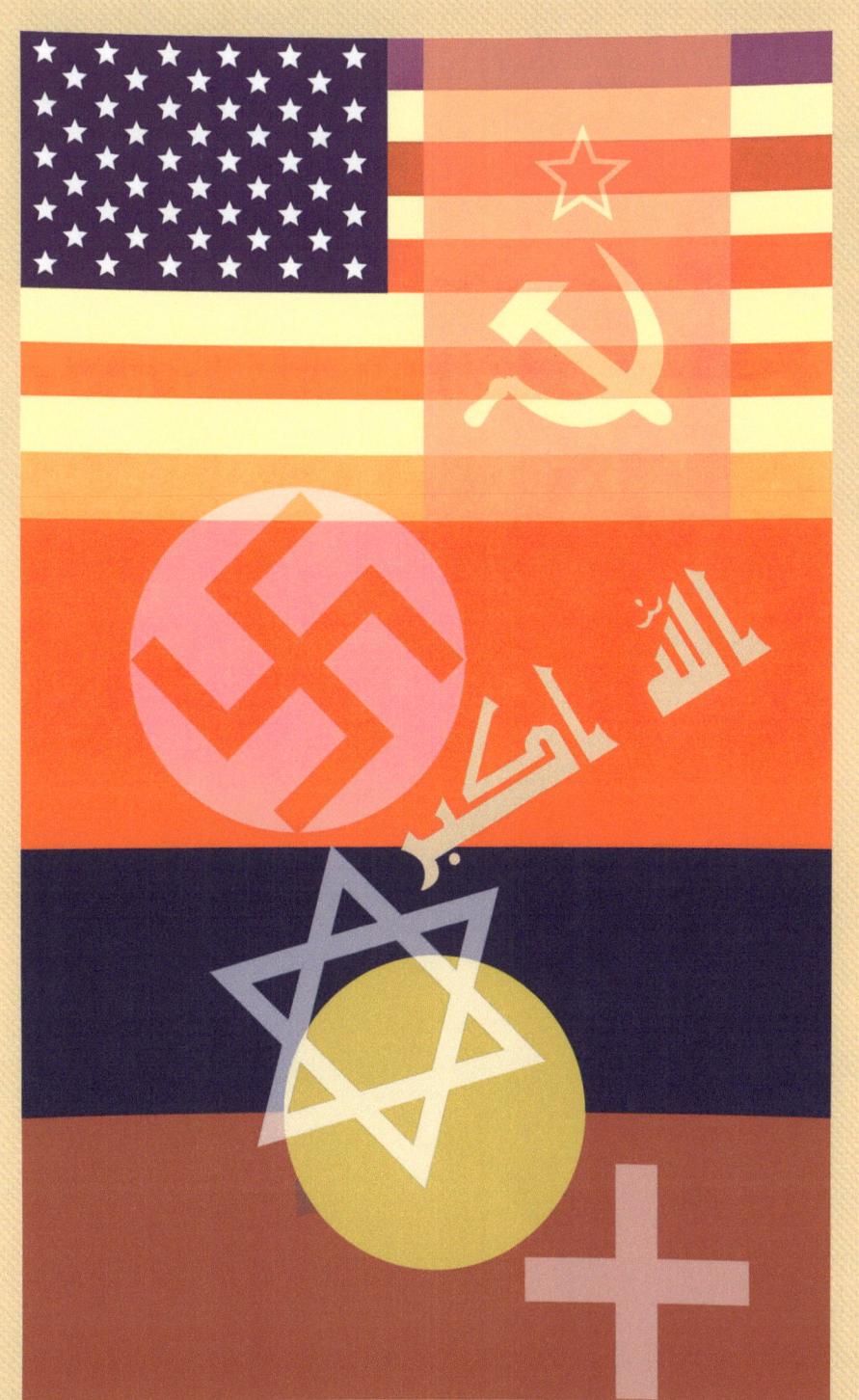

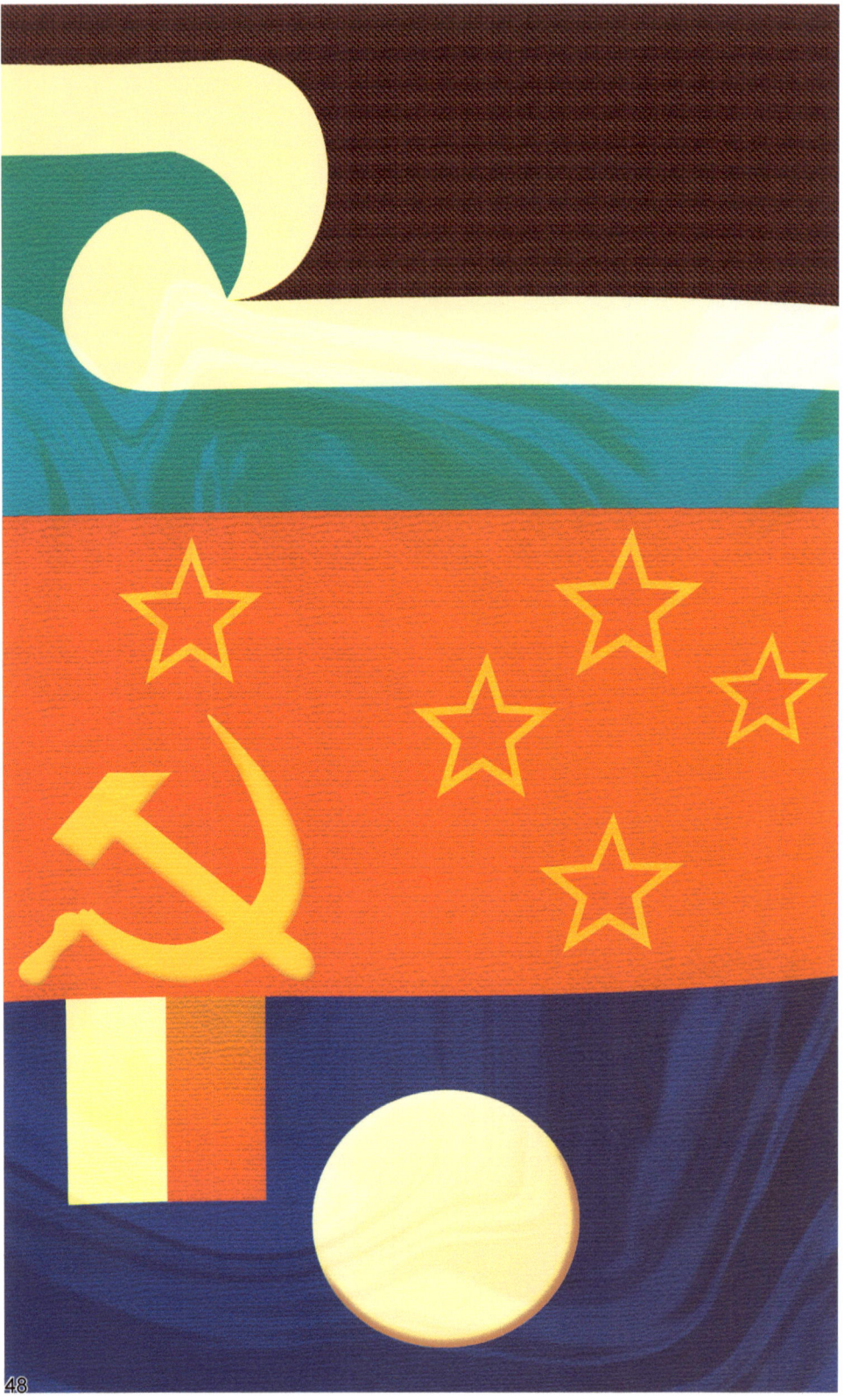

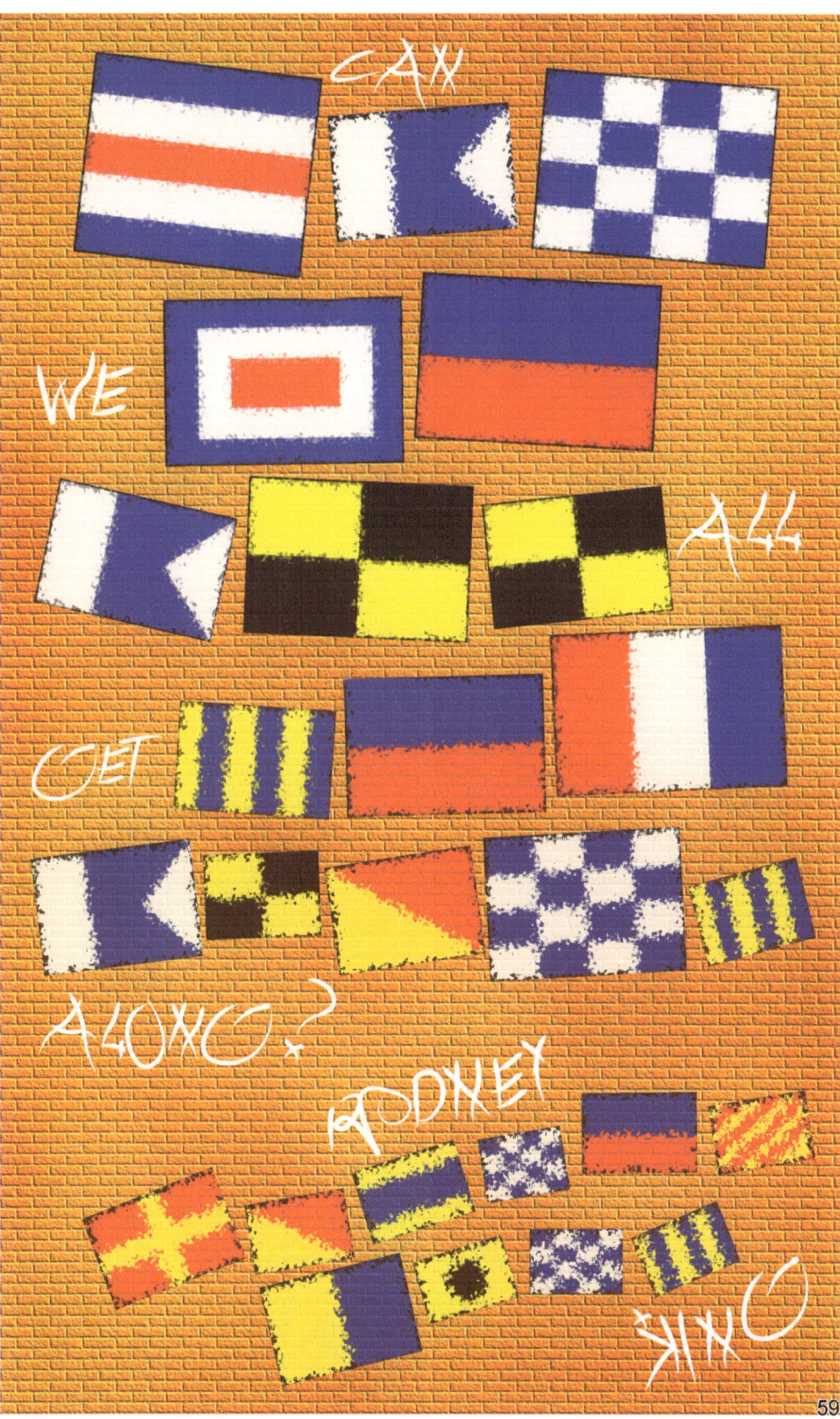

POSTFIX

On March 3, 1991 Los Angeles Police Department officers ended a high-speed car chase with the beating of the driver, Rodney Glen King. A witness videotaped much of the beating from his balcony. The video, nationally broadcasted, showed four officers repeatedly striking the intoxicated driver, Rodney King, while other officers watched. Later four officers were charged with assault. None were found guilty. A result was the 1992 Los Angeles riots which killed 53 people, injured over 2,000, and started 7,000 fires. Small riots were repeated in Los Vegas, Nevada, Atlanta, Georgia, and Toronto, Ontario. A whole nation questioned the relationship between police and minorities. During these riots Rodney King, in a plea for **PEACE**, made a television appearance in which he said, *"Can we all get along?"*

At the time of this event my son was a senior at our local Milby High School in Houston, Texas. In a mixed community the national racial issue was central in the minds of every young male. Rumors, perhaps true, perhaps not, were floated. The black students had made plans to push white students down stairs; the KKK was going to surround the school to protect white students; students were hiding guns in the trunks of their cars. Gangs were preparing. Hispanic friends of my son offered him protection when he changed classes. When evening came and my son returned home, a **COLD WAR** had ended in **PEACE**. The answer to *"Can we all get along?"* was **YES**. A potential riot at one of the largest high schools in our county was a **NON EVENT**. **Can we celebrate the NON EVENTS?**

Glen Smith